The
Amish Drawings
of
Florence Starr Taylor

The
Amish Drawings
of
Florence Starr Taylor

Text by David Graybill

Good Books®

Intercourse, Pennsylvania 17534

Acknowledgments

The photo of Florence Starr Taylor on page 14 (right column) was taken by Richard Hertzler, Lancaster *New Era*, and is used by permission of the newspaper.

The publishers wish to thank Ron Ettelman for his help in selecting drawings for the book and obtaining permission to use them. Thanks also to the many contributors who allowed drawings from their collections to be included here: Beth Adams, "In Mother's Steps"; Mr. and Mrs. Bock, "Boy with Black Hat"; Mr. and Mrs. Edward W. Cook, "Trading Wisdom"; Mr. and Mrs. Terrell Esterly, "Grandfather"; Ron Ettelman/Dream Framer Collection, "Amish Faces", "Beilers' Kitchen," "Showing the Way" and "Men on a Wagon"; Mike Frantz, "Schoolboy"; Alan Fredericksen, "Putting up a Barn"; Mr. and Mrs. Vernon Glick, "Bus Stop" and "Leaving the Graveyard"; Mr. and Mrs. Giesland, "Studies of Man" and "Studies of Woman"; Mr. and Mrs. John F. Graham, "Study of Girl"; Wilbur J. Graham, "The Bishop"; Rudolph O. Grob, "Market Scenes"; Kenneth M. Hoak, "Eli"; Richard H. Hopf, "Shopping at Garvins"; Jane Heller, "Catching Up"; Dr. and Mrs. Norman B. Kornfield, "Age"; Malone House Collection, "Boy with Cat," "Portrait, John Beiler" and "Tic-Tac-Toe"; Mr. and Mrs. Arno E. Richter, "Discing Time"; Mr. and Mrs. D. Currey Pettus, "Distant Thoughts"; Mr. and Mrs. Dennis Varholi, "Boy Whittling," "Carrying Eggs" and "The Horse Knows the Way."

The Amish Drawings of Florence Starr Taylor

International Standard Book Number: 0-934672-55-5
Library of Congress Catalog Card Number: 87-20895

Copyright © 1987 by Good Books, Intercourse, PA 17534
Design by Craig N. Heisey

Table of Contents

Table of Drawings 7
The Artist 11
Seedtime and Harvest 17
Across the Fence 29
Times Together 45
Going to Town 61
Patience, Strength and Hope 75
A Word About the Amish 93
Suggested Readings 94
The Author 96

Table of Drawings

Early Self-Portrait 12
Discing Time 18
Distant Thoughts 19
Boy with Cat 20
Tire Swing 21
Wheat Harvest 22
Leading Mules 23
Carrying the Load 24
Beilers' Kitchen 25
Shining the Mirror 26
Street Peddling 27
Contemplation 30
Men on a Wagon 31
Confidence 32
Classroom Reading 33
On the Move 34
Man with Cigar 34
Schoolboy 35
Study of Boy 36
Catching Up 37
Carrying Eggs 38
Age 39
Amish Madonna 40
Old Order Mennonite 40
Boy with Large Hat 41
Early Manhood 42
A Summer Walk 43
Showing the Way 46
In Mother's Steps 47

Getting There Together	48
Going for a Ride	49
Winter Travel	50
Trading Wisdom	51
Selling by the Road	52
Amish Faces	53
Saying Goodbye	54
Leaving the Graveyard	55
Studies of Man	56
Studies of Woman	57
Putting up a Barn	58
Grandfather	59
Bus Stop	62
Shopping at Garvins	63
The Horse Knows the Way	64
Market Scenes	65
Study of Bonnet	66
Winter Wear	66
Country Store	67
Bargains in Town	68
Comparison Shopping	69
Working Day	70
Selling in the Rain	71
Meeting Friends	72
Horse with Blanket	73
Simple Faith	76
Eli	77
Tic-Tac-Toe	78
Boy with Black Hat	79
Swinging	80
Careful Steps	80

Plain Mennonites	81
Stopping on a Hill	82
The Bishop	83
Barn on Lititz Pike	84
Study of Girl	85
Taking the Reins	86
Portrait, John Beiler	87
School Days	88
Going Her Own Way	89
Boy Whittling	90
Going Home	91

The Artist

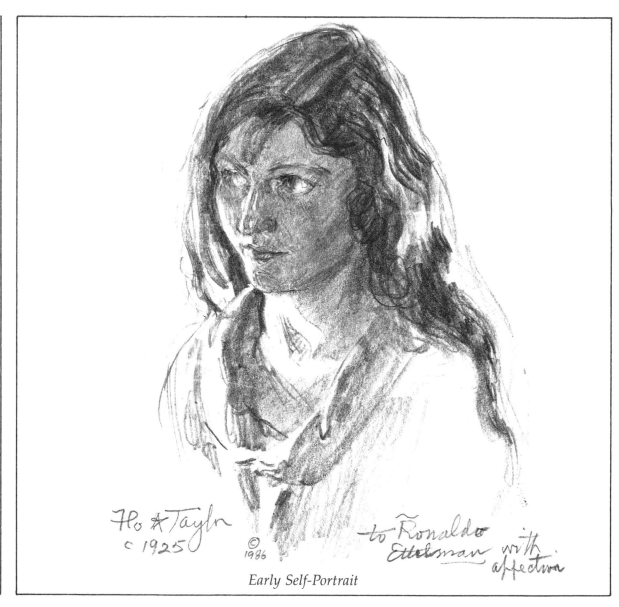

Early Self-Portrait

Few people have captured the spirit of the Amish like Florence Starr Taylor. In the 70 pencil and pen-and-ink drawings collected here, this exceptional artist provides glimpses of Amish work, home and social life in the first half of this century, as well as scenes of the countryside in which these people lived. Sympathetic but unsentimental, her work evokes the quiet strength of a religious community and the beauty of a simpler, rural time.

A native of Lancaster, Pennsylvania, Florence has spent all but four of her 83 years in the area that has the second-largest Amish community in North America. Exuberant in temperament and appearance, she seems the opposite of the quiet, austere Amish. Yet as the brilliantly-colored quilts of the Amish reveal an unexpected zest for life, Florence's work reflects a surprising simplicity and appreciation for traditional values. Florence says she was first attracted to the Amish because "they're picturesque, they're very drawable." But the affinity clearly goes deeper. With the Amish she shares a love of the lush, rolling countryside and sweeping vistas of Lancaster County; with them she shares a deep skepticism about the benefits of development that turns rich farmland into shopping malls, outlet centers and suburban apartments.

There is also the attraction of a nonconforming mind to a nonconforming people.

The Amish "are very different from the rest of us," she says. "I'm interested in that."

Florence was born in what she calls "pasteboard row" on North Duke Street in Lancaster, a town noted for Franklin and Marshall College, steamboat inventor Robert Fulton and the acclaimed 20th century artist Charles Demuth. Her date of birth, she notes, is the fourth day of the fourth month of 1904. ("And I'm the fourth child in the family, too. Four must mean something.")

Florence Waters Taylor, as she was known then—she got her middle name from an aunt on her father's side, and changed it after the woman's death—showed an interest in art very early in life. "I'm told I drew before I could talk," she says.

Growing up, she knew in spite of skeptical adults that she would make her living as an artist: "That was what I had to do. And I had to make pictures that looked like the people I was drawing." As she says in a typically playful turn of phrase, "I like to do a likeness of the things I like."

Florence's Amish drawings are only a small part of her exceptionally varied output. A graduate of the Philadelphia Museum School of Art (now Philadelphia College of Art), she got her first art job in 1926 as an illustrator for the Lancaster *Intelligencer*, one of the city's daily newspapers. During her two years there she made drawings

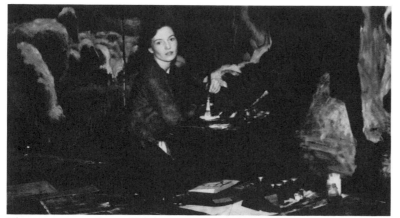

Florence at work, c. 1930

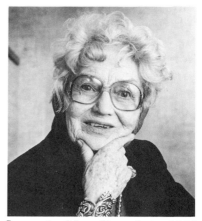

Lancaster New Era *photo, 1986*

of everything from shoppers at farmers' markets to trial scenes to sports events. From the paper she moved to the Hamilton Watch Company, where she was an artist in the advertising department for five years. In 1934 she began to free-lance full-time, illustrating books and calendars and making pastel portraits, a medium in which she is still active.

Florence was staff illustrator at WITF, a public television station in Hershey, Pennsylvania, from 1964 to 1970. In addition, she has been a volunteer staff artist for the past 30 years at the North Museum on the campus of Franklin and Marshall College, and she has contributed portraits and designed promotional pieces for numerous charities in the Lancaster area. She received the Red Rose Award, the city of Lancaster's highest honor, in 1986.

Although Florence made a set of Amish drawings for a television special in the late 1960s, the drawings in this collection come from the early and middle years of her career, the 1920s, '30s and '40s. They show Lancaster and the Amish as they were before the larger world discovered them.

This quieter period is a time Florence remembers fondly. "I used to ride my bike out of the center of town two miles and there would always be something to paint—beautiful country," she recalls with just a hint of exaggeration. "There isn't now. And the traffic!"

For two weeks in 1925, Florence lived on an Amish farm near New Holland, paying $3 a week for board. The family wouldn't pose, she recalls, but didn't mind being sketched while they worked. Florence particularly liked the children, and even went

with them to sell ice cream on the street.

Some of the Amish drawings are from this period, others from the time she worked at Garvins, a department store in Lancaster City frequented by Amish and plainly-dressed Mennonites. Still more are from her travels and observation around the County, in villages such as Intercourse and Bird-in-Hand. Along with drawings of Old Order Amish are a few sketches of houses, animals and roadside scenes, and drawings of individuals from other plain groups.

Many of the works were sketched quickly as studies for watercolor; only a few were ever completed in their intended form. ("I do not get things done," Florence says with characteristic candor. "I start them and I don't finish unless someone is cracking the whip.") As Florence notes, however, it is this same incompleteness that gives the drawings energy and a sense that the viewer is present at the scene.

A paradoxical desire for both immediacy and precision is evident in Florence's list of artists who have influenced her. The Dutch painter Hans Halls, she says, does portraits "just the way I'd like to—brash. The brush strokes show. Done in a hurry. It's lively."

"Holbein I like too, but it's the opposite," she continues. "Very gentle, but you know every line is precise."

Florence also admires the work of Charles Demuth ("He did watercolor like nobody before him did."), the French caricaturist Daumier, Howard Pyle and William Blake.

Of all the media she has used, Florence says she prefers pastel—"because you can change it." At the same time, "pencil is the closest thing to you," she says. "It's what you start with. I love pencil."

Although her portraits have often been exhibited in Lancaster, Florence's Amish drawings did not receive public attention until 1986. A show of her work early in that year included "six or seven drawings that the people had put up because the wall was empty." Ron Ettelman, now her agent, saw them and asked if she had more. She did— several hundred drawings, many of them on paper scraps or envelopes, that had been hidden in a cardboard box for decades. Ettelman organized a show that fall in which 67 works were exhibited. Forty-nine sold during the show.

For Florence, who admits she is "not a big name . . . except maybe locally," the response was both a surprise and a vindication. She takes great pleasure in relating the comments of a teacher she had in art school, who looked at several of her early drawings of the Amish and told her: "That's too limited. I don't think it has wide appeal."

Time will judge. But Florence Starr Taylor, still vibrant in her eighth decade, seems to have the years on her side.

15

Seedtime and Harvest

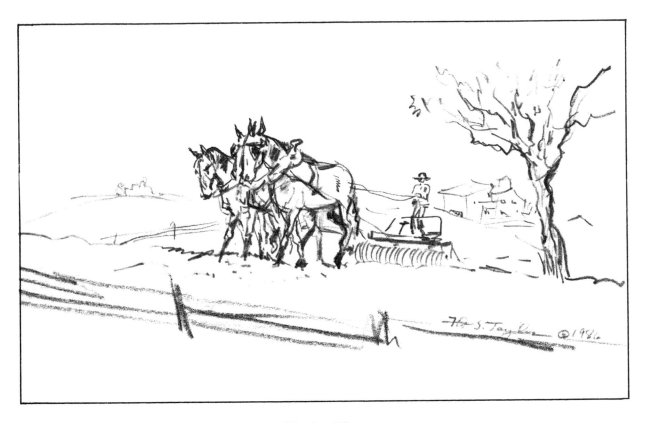

Discing Time

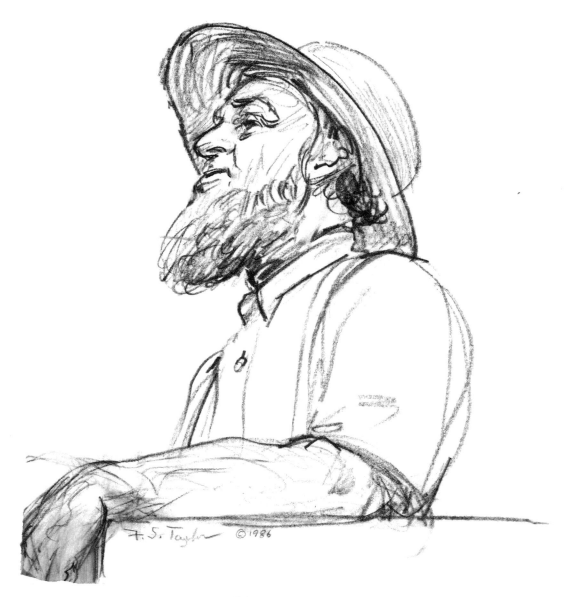

Distant Thoughts

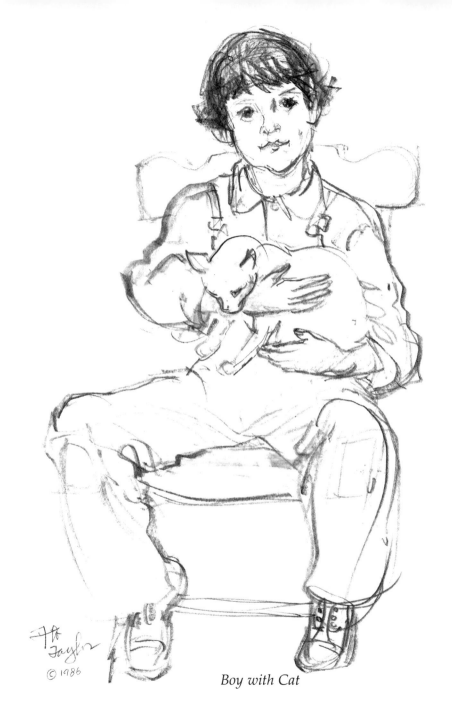

Boy with Cat

20

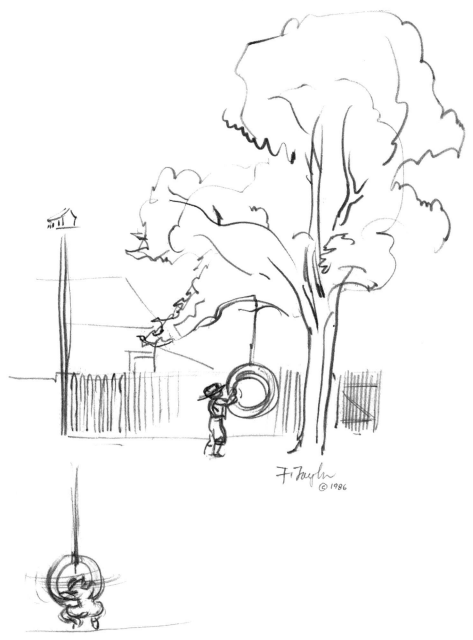

Tire Swing

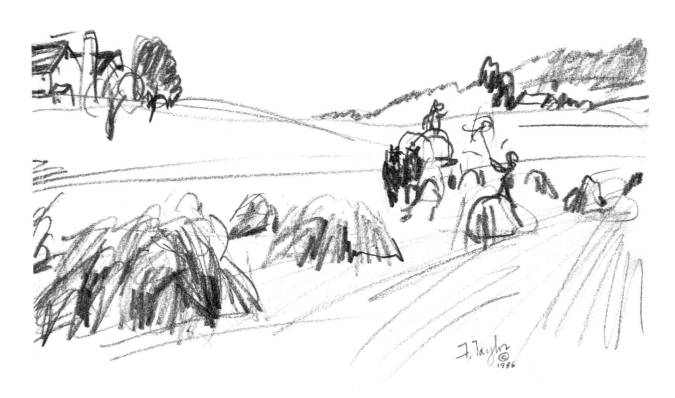

Wheat Harvest

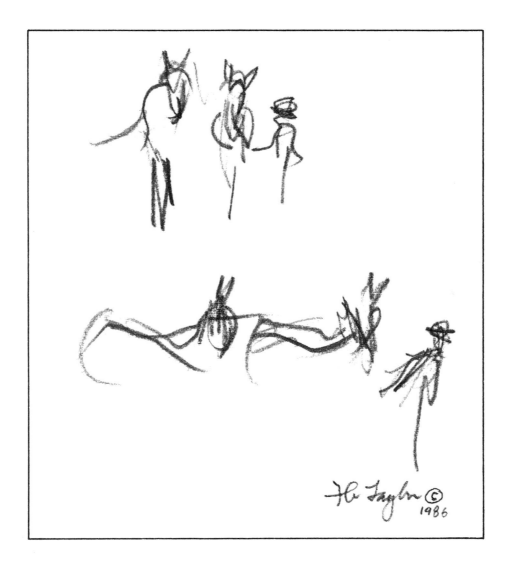

Leading Mules

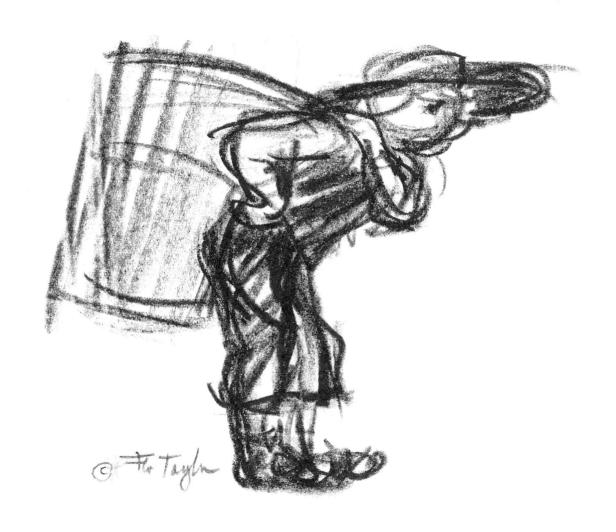

Carrying the Load

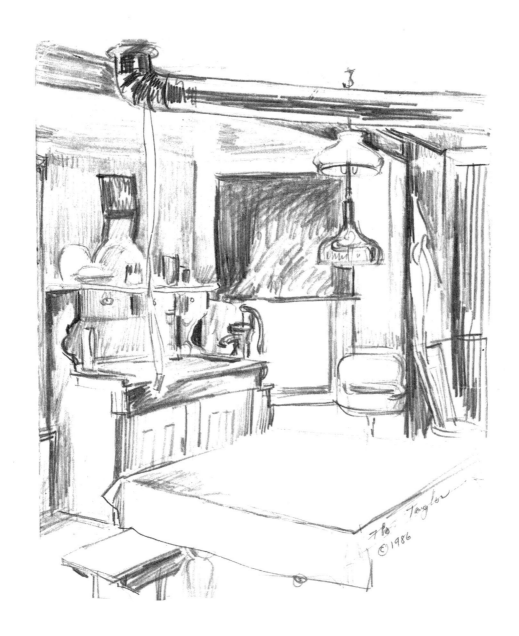

Beilers' Kitchen

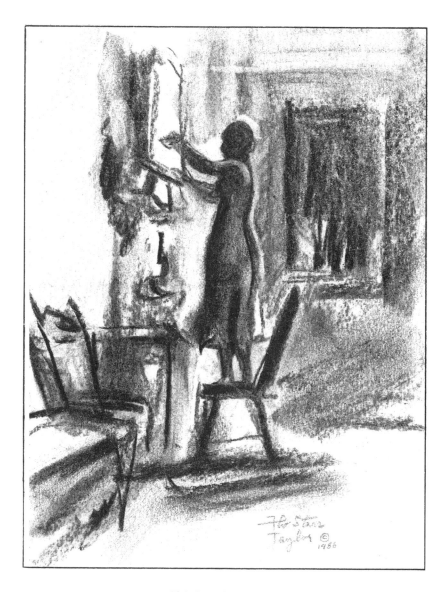

Shining the Mirror

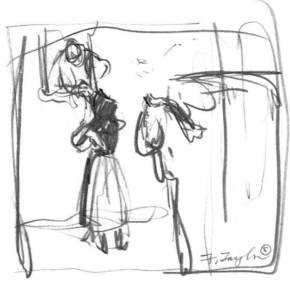

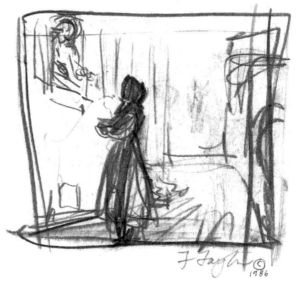

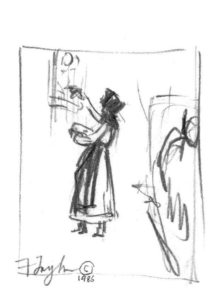

Street Peddling

Across the Fence

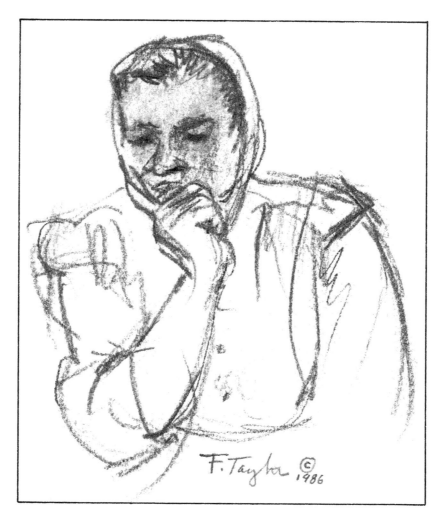

Contemplation

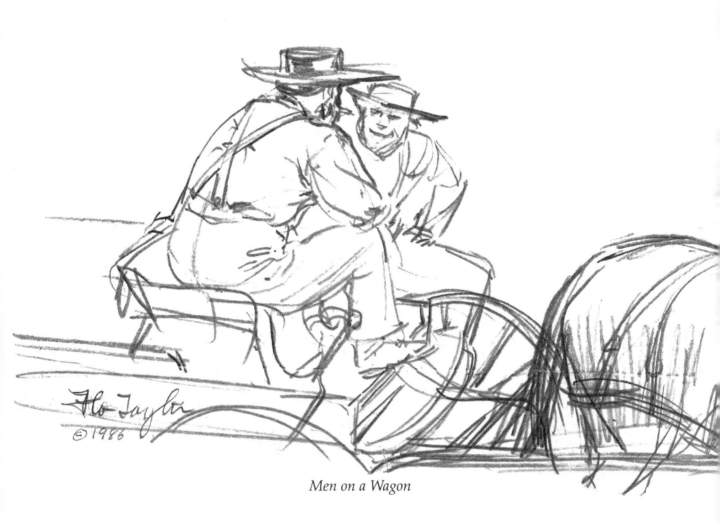

Men on a Wagon

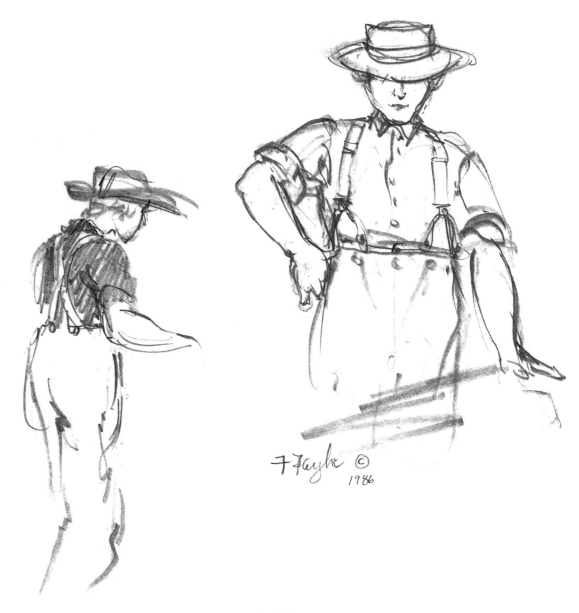

Confidence

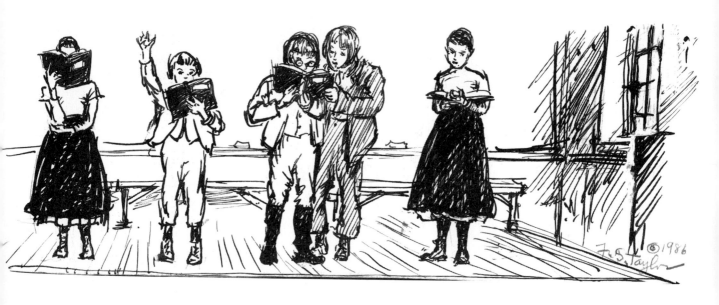

Classroom Reading

On the Move

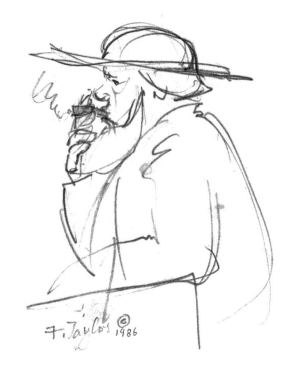

Man with Cigar

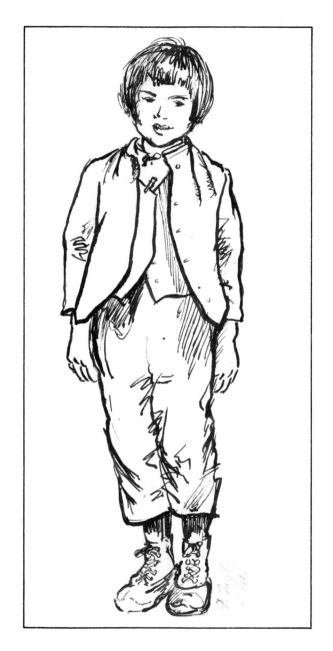

Schoolboy

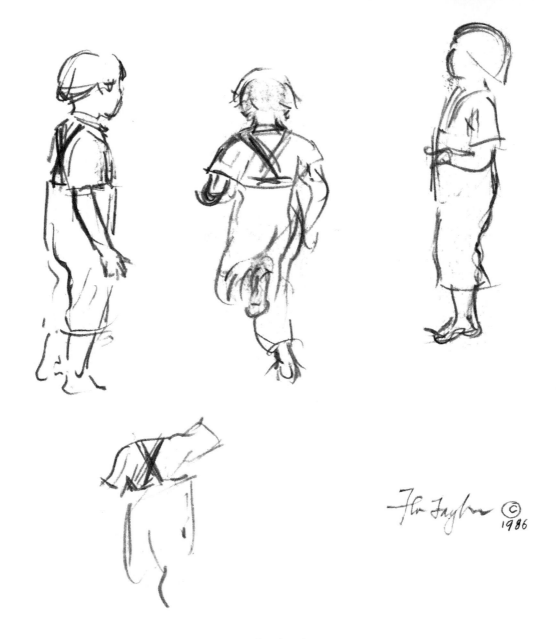

Study of Boy

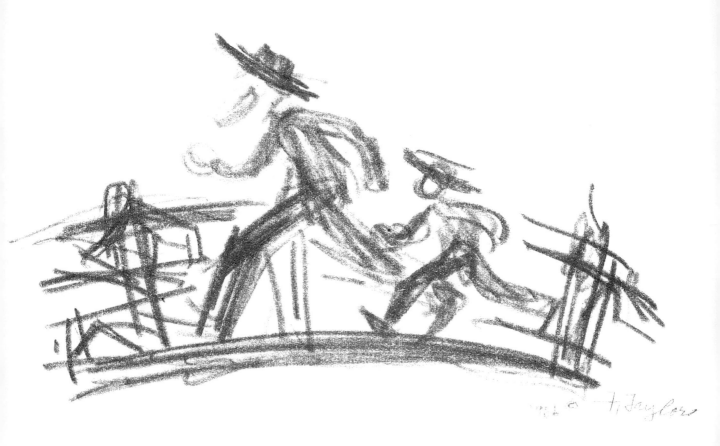

Catching Up

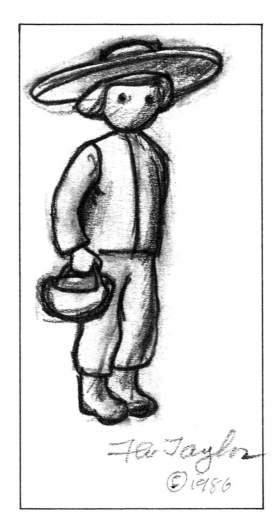

Carrying Eggs

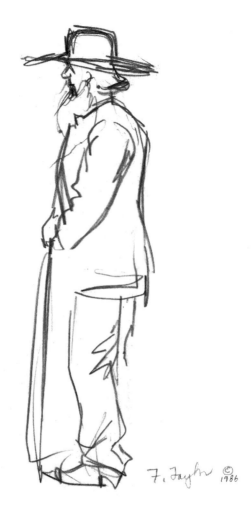

Age

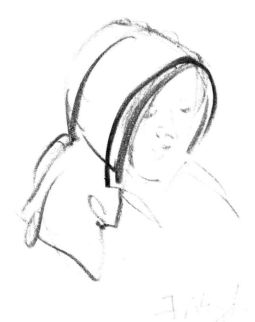

Amish Madonna © 1986

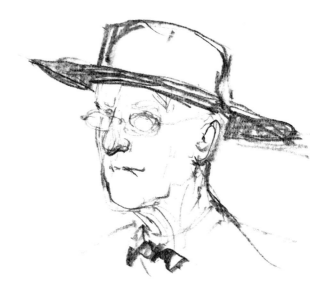

Old Order Mennonite

40

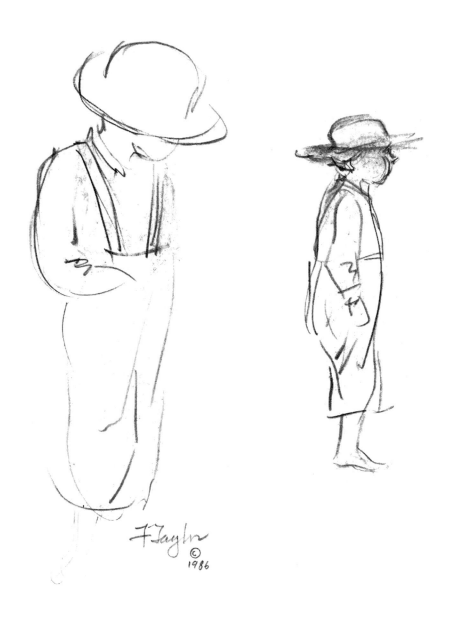

Boy with Large Hat

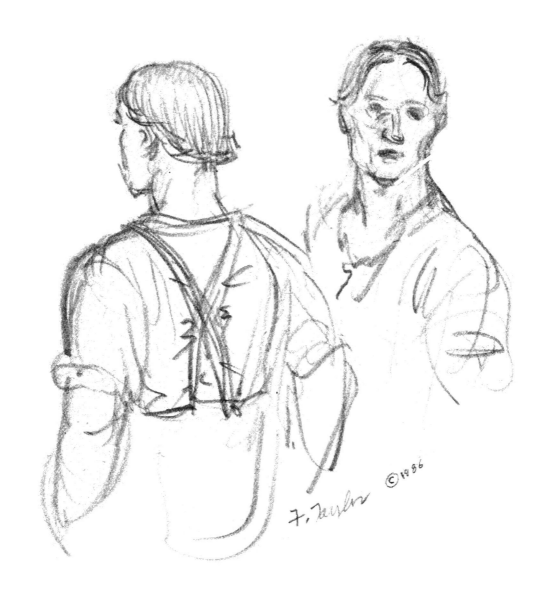

Early Manhood

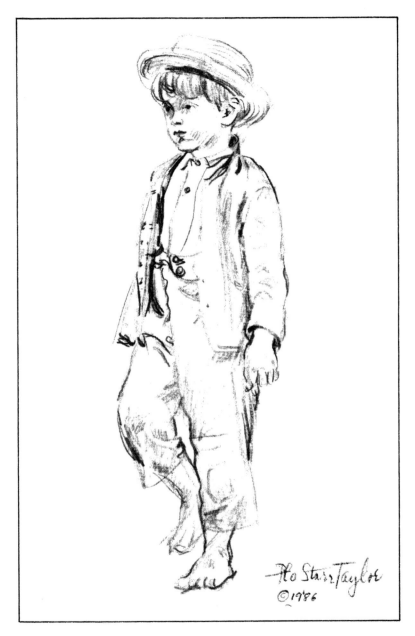

A Summer Walk

Times Together

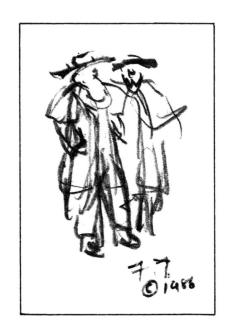

Showing the Way

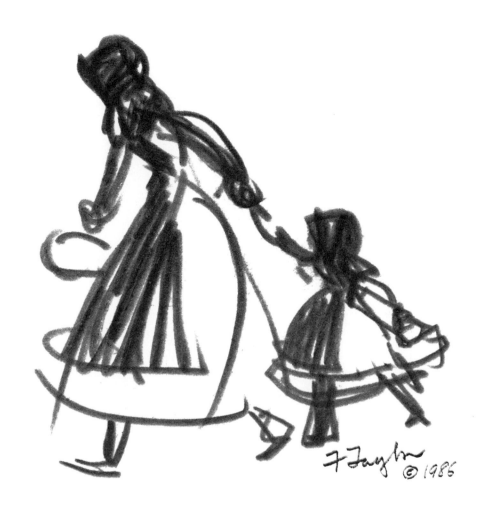

In Mother's Steps

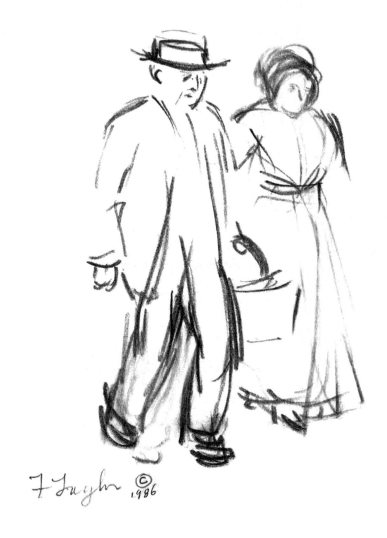

Getting There Together

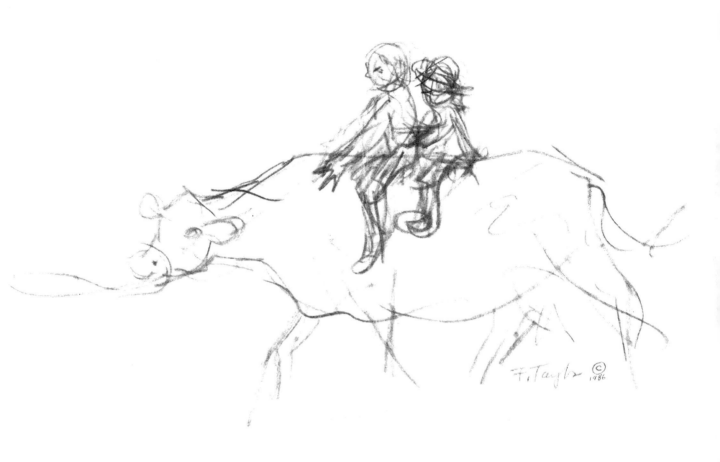

Going for a Ride

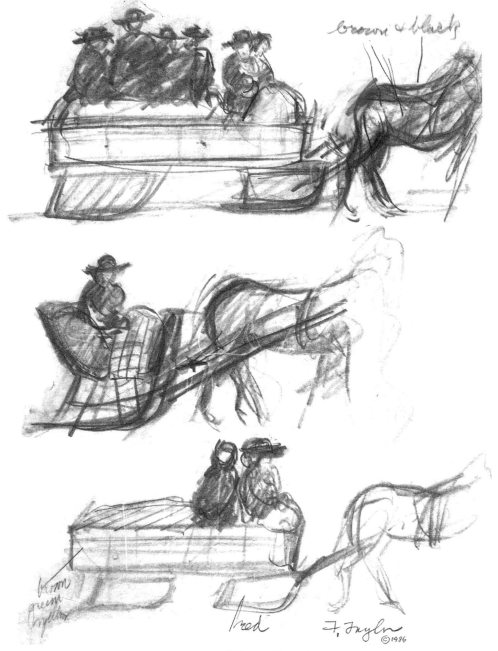

Winter Travel

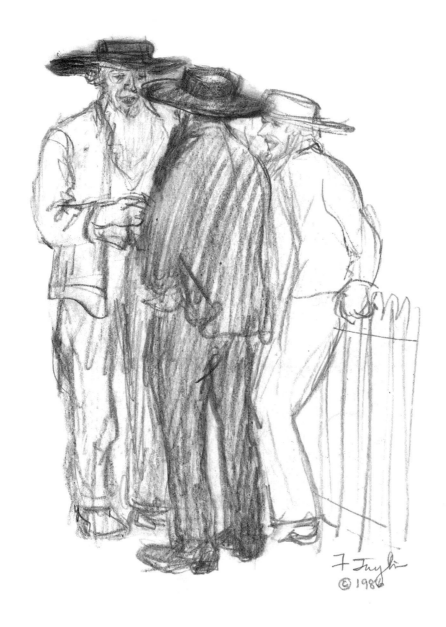

Trading Wisdom

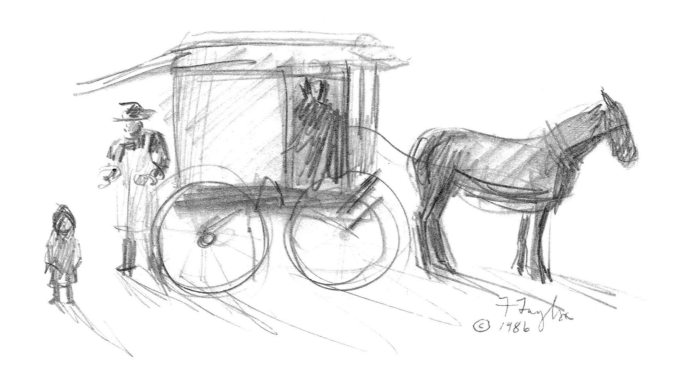

Selling by the Road

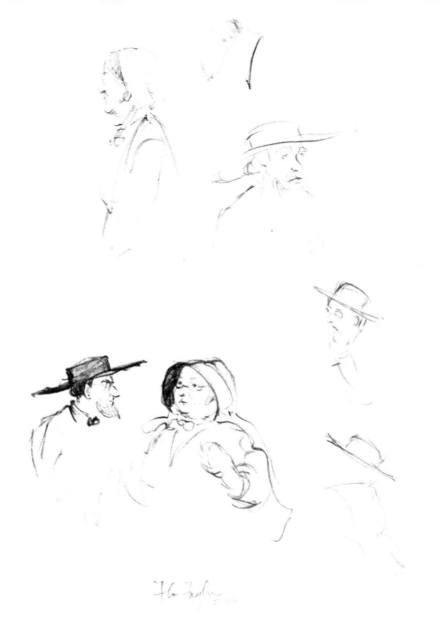

Amish Faces

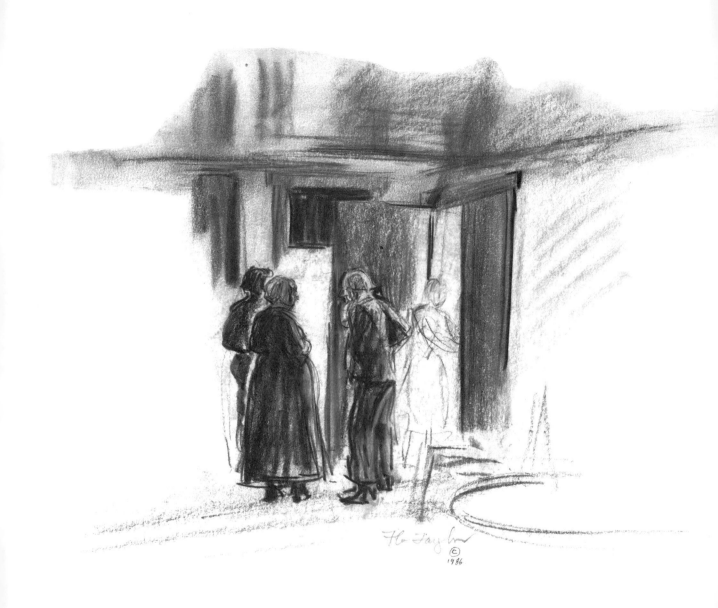

Saying Goodbye

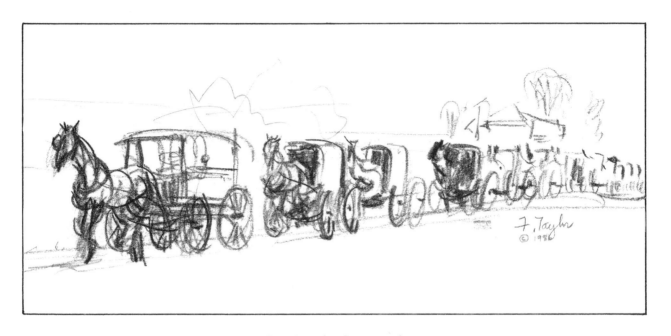

Leaving the Graveyard

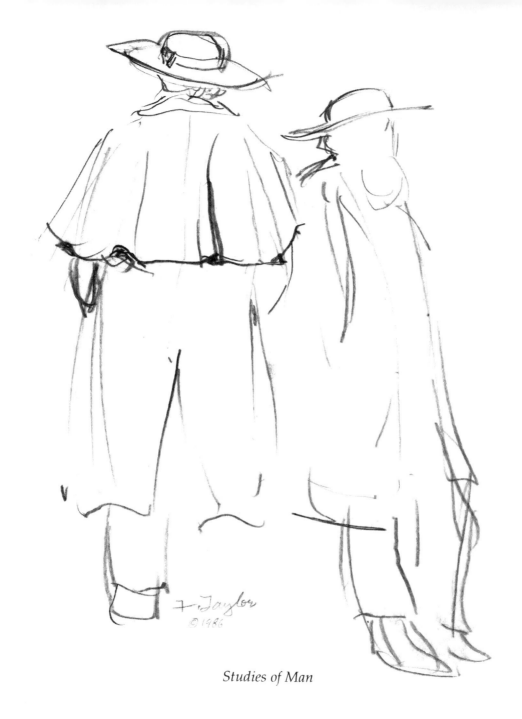

Studies of Man

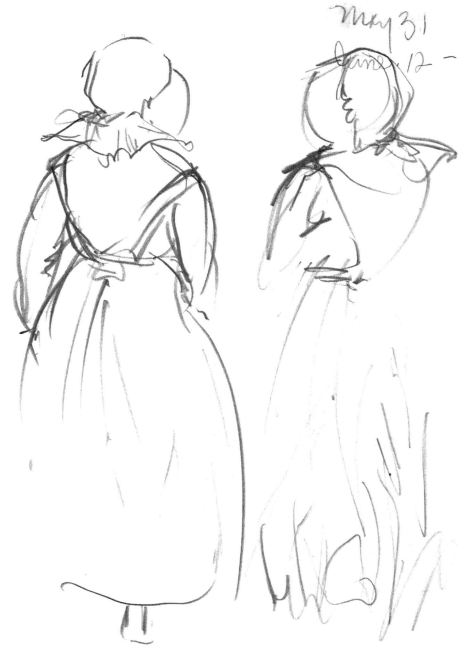

Studies of Woman

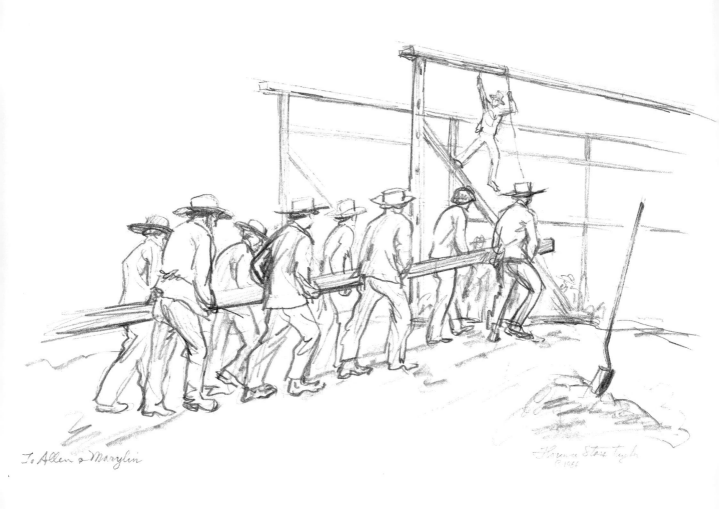

To Allen & Marylin

Florence Starr Taylor
© 1986

Putting up a Barn

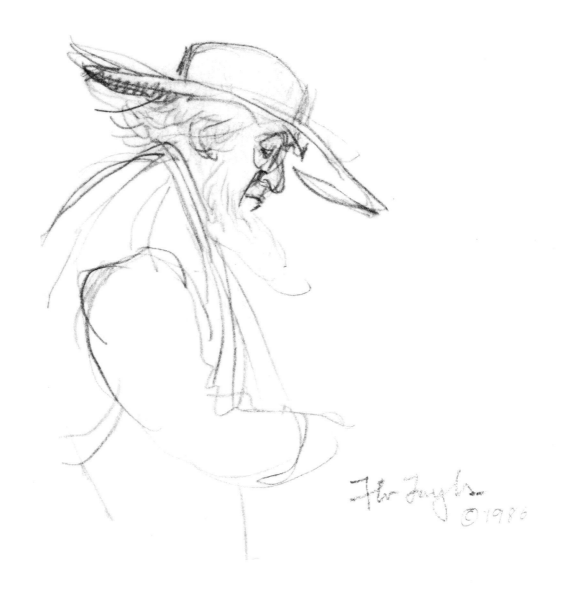

Grandfather

Going to Town

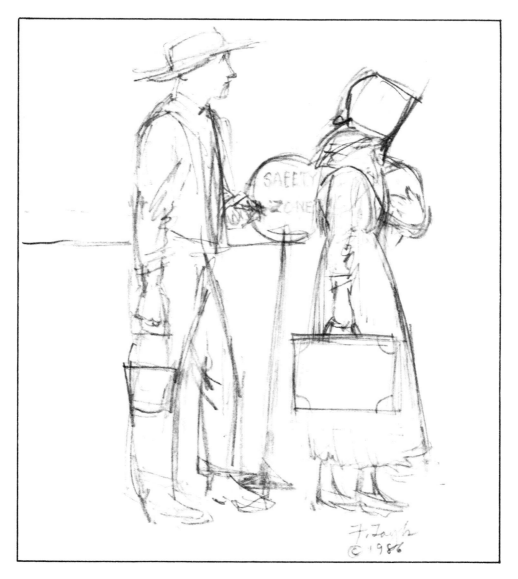

Bus Stop

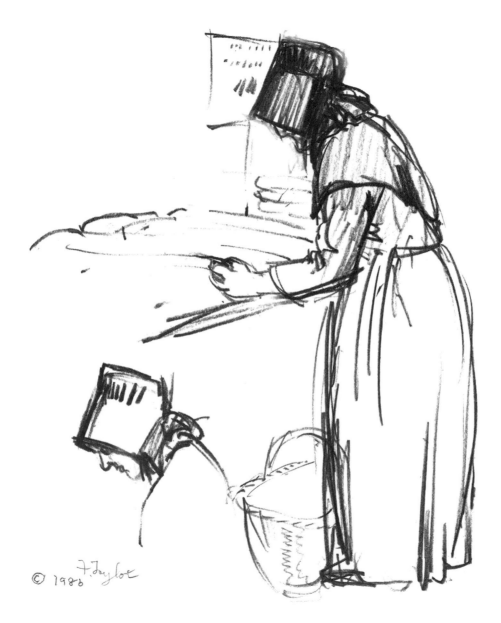

Shopping at Garvins

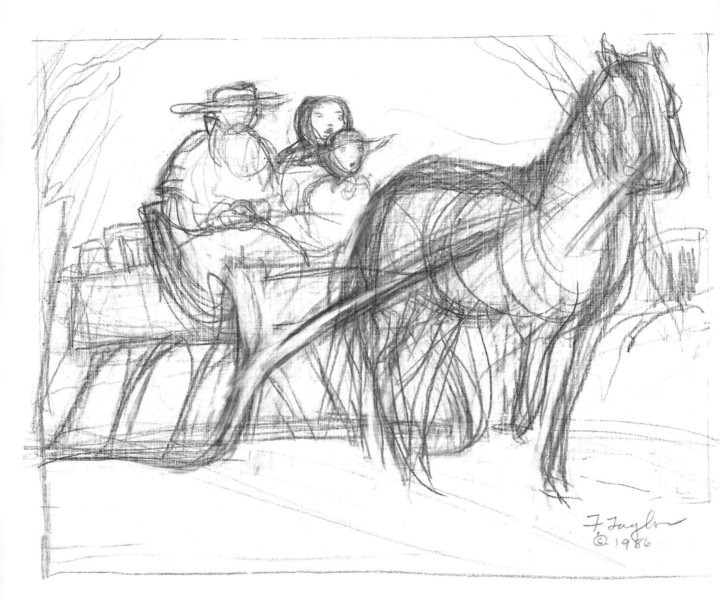

The Horse Knows the Way

64

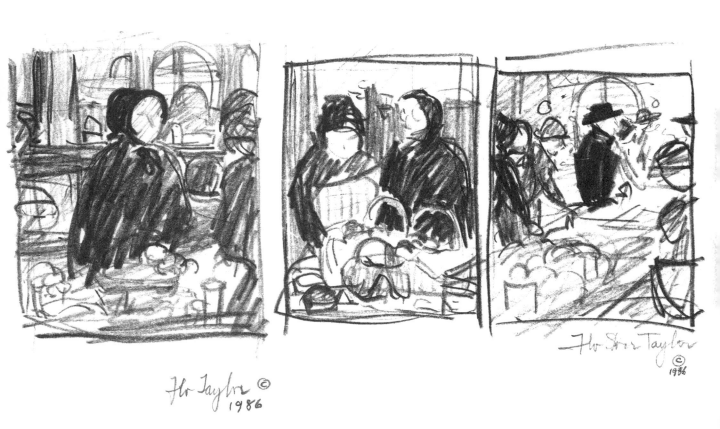

Market Scenes

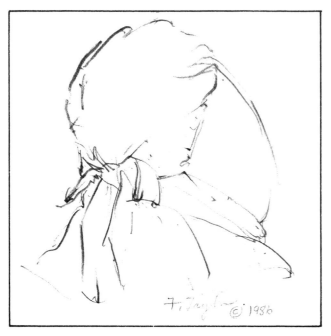

Study of Bonnet

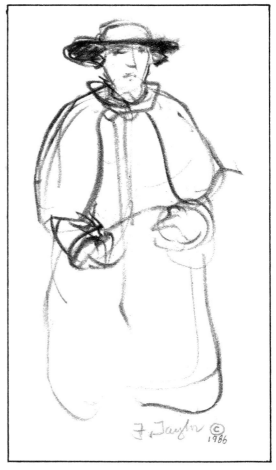

Winter Wear

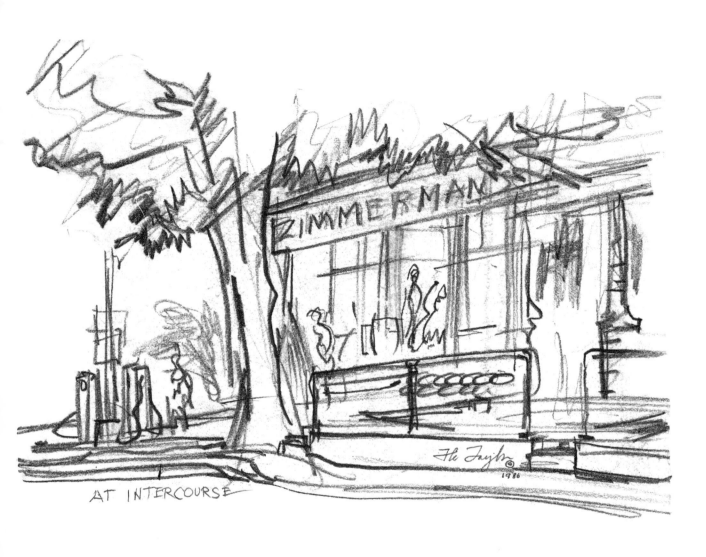

Country Store

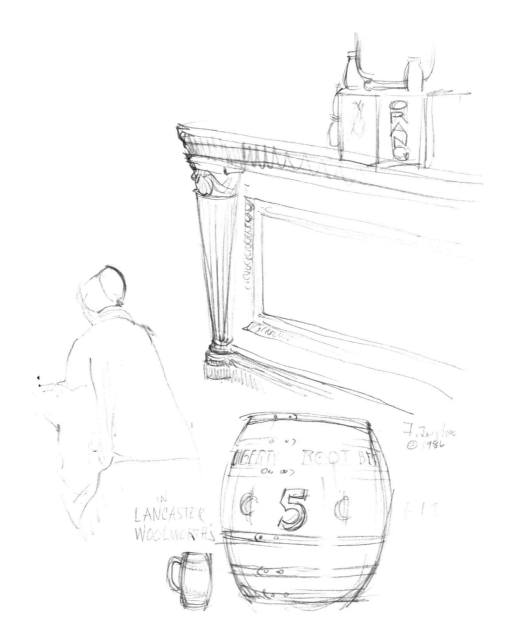

Bargains in Town

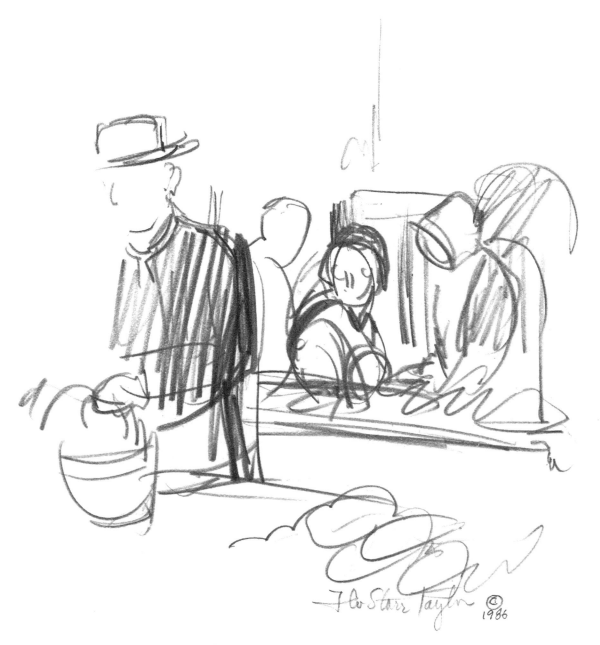

Comparison Shopping

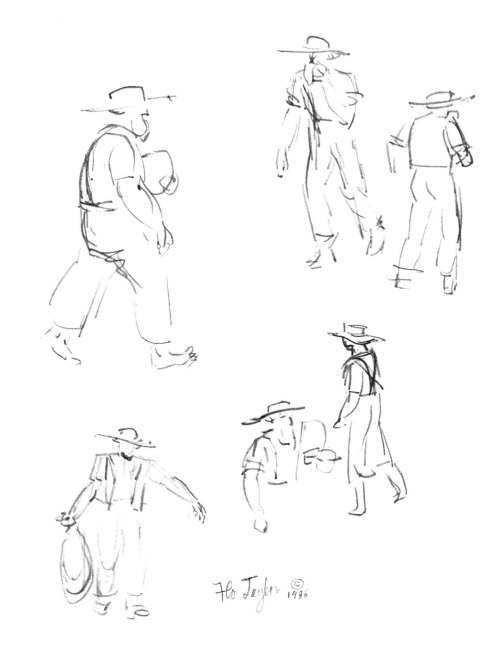

Working Day

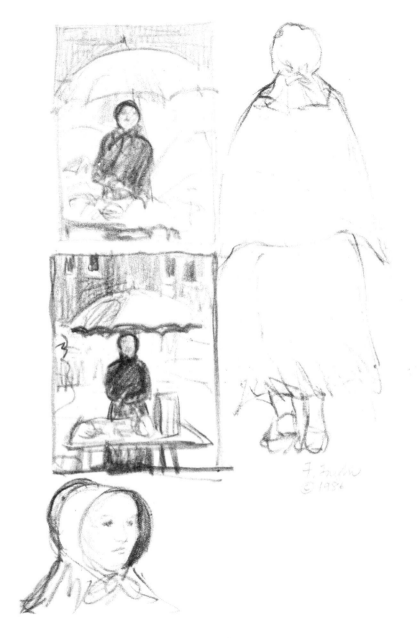

Selling in the Rain

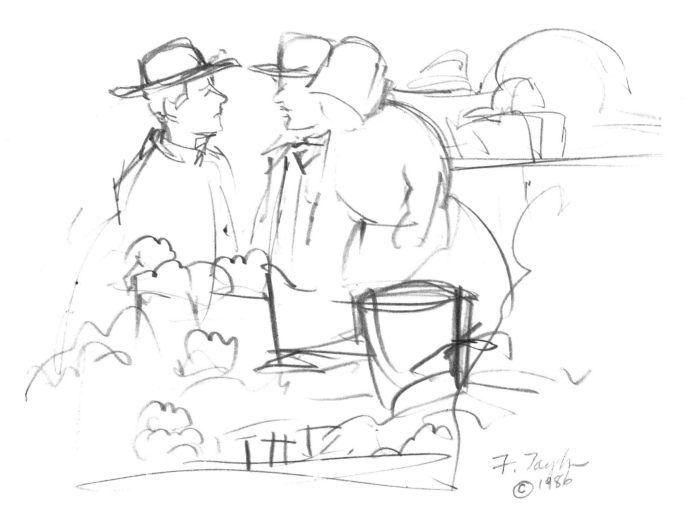

Meeting Friends

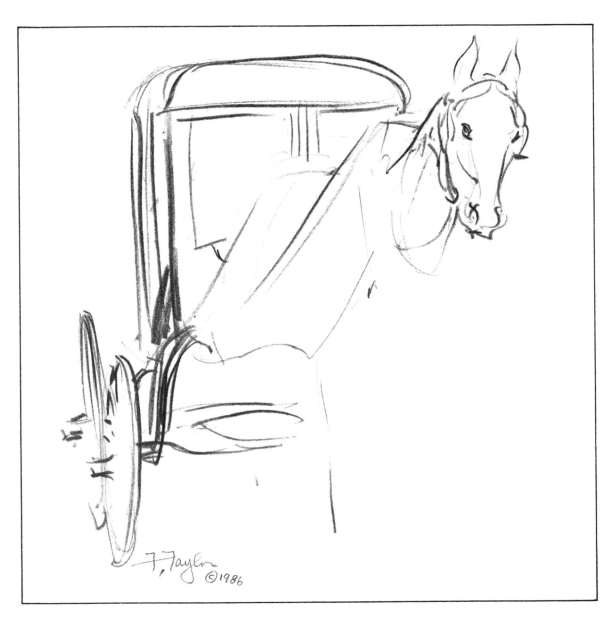

Horse with Blanket

Patience, Strength and Hope

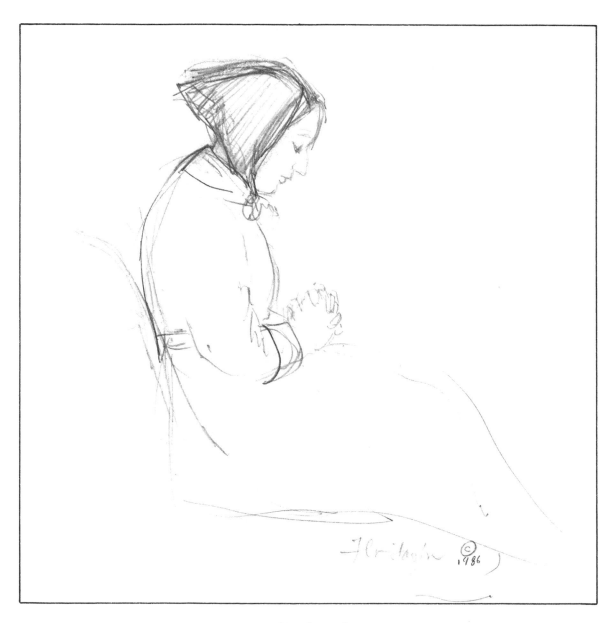

Simple Faith

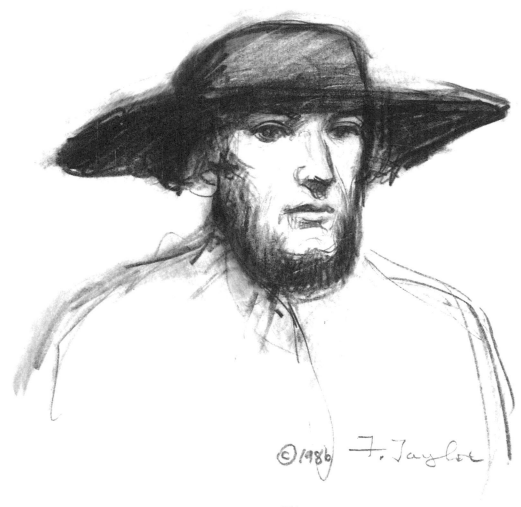

Eli

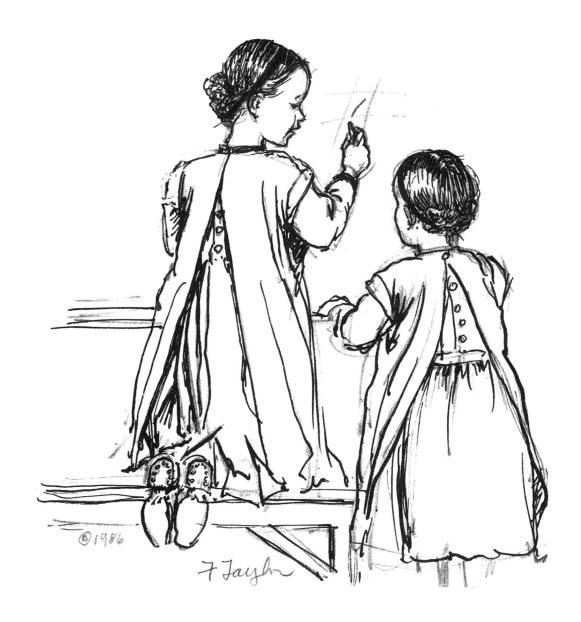

Tic-Tac-Toe

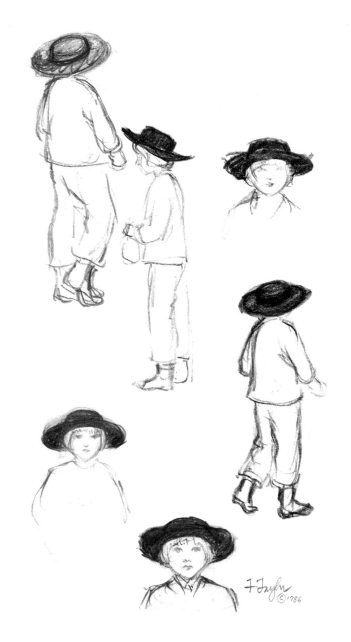

Boy with Black Hat

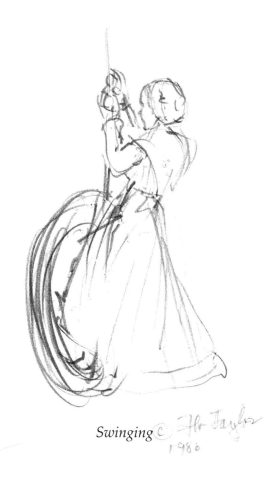

Swinging © Flo Taylor
1986

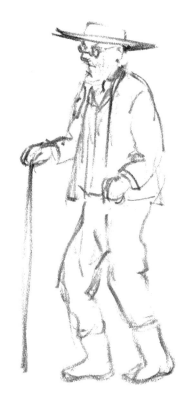

F. Taylor
© 1986

Careful Steps

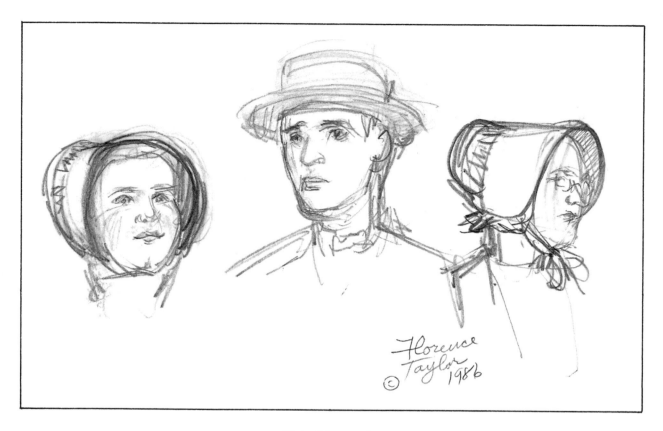

Plain Mennonites

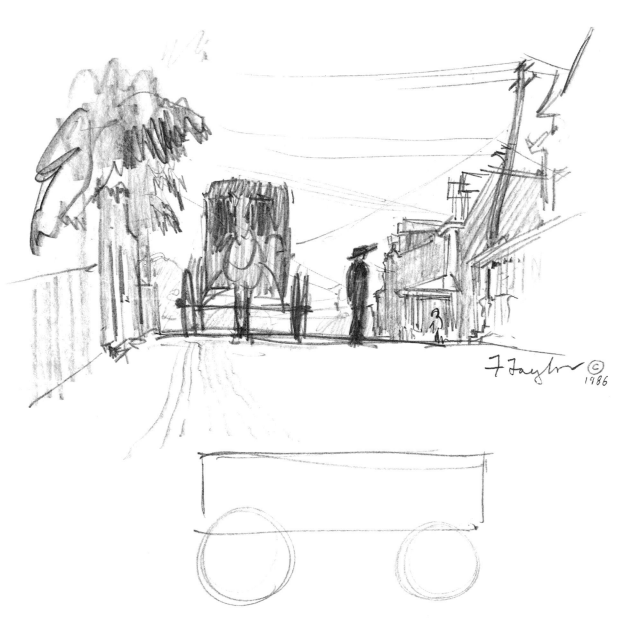

Stopping on a Hill

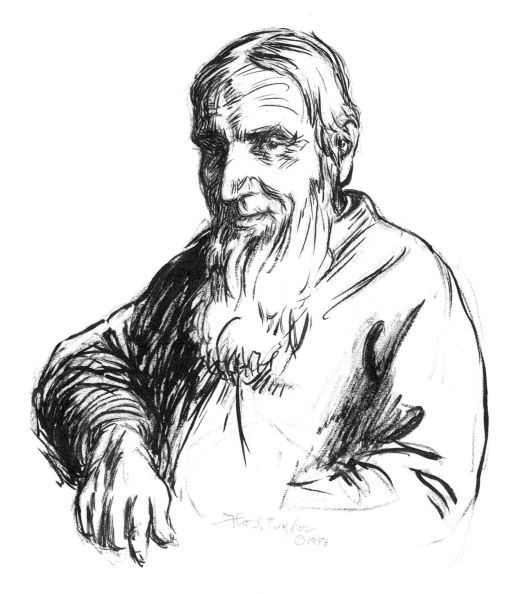

The Bishop

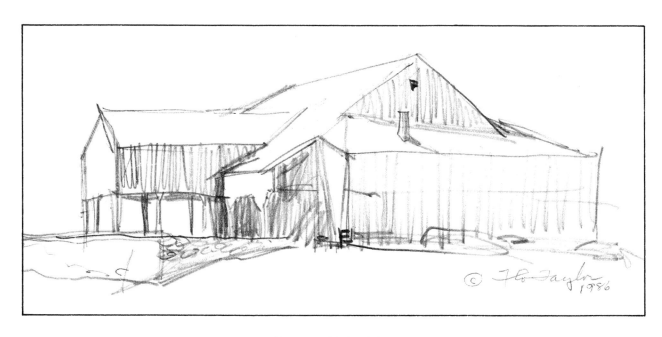

Barn on Lititz Pike

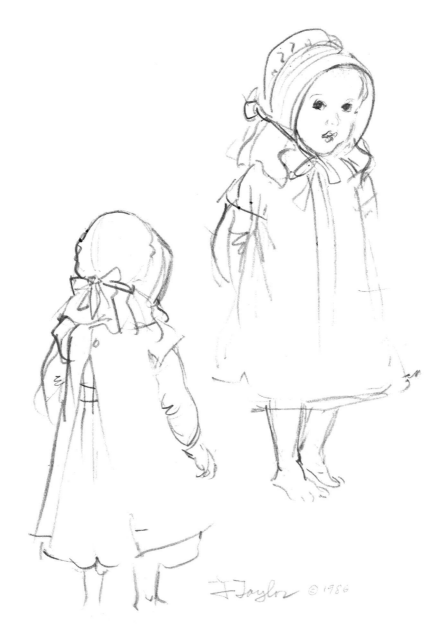

Study of Girl

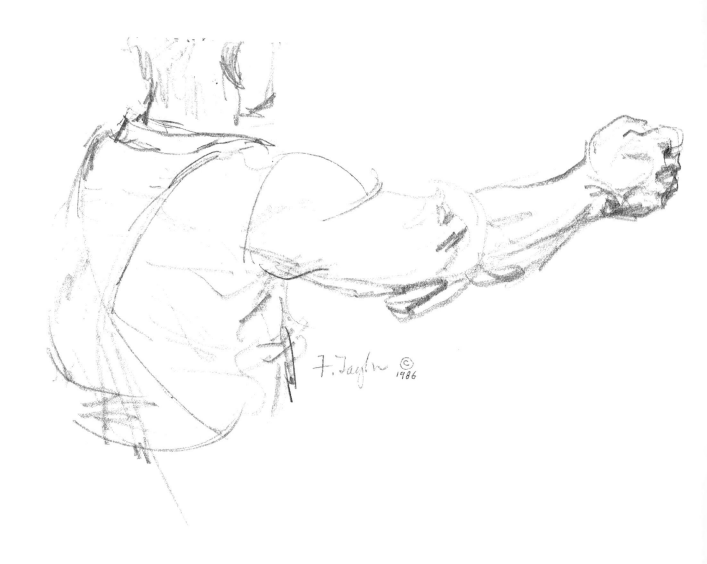

Taking the Reins

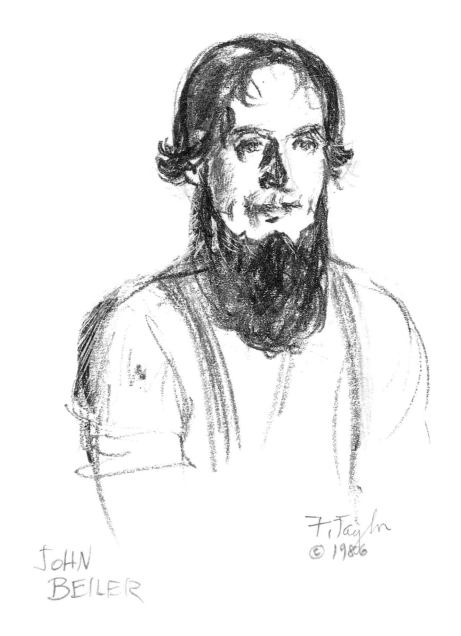

JOHN
BEILER

F. Taylor
© 1986

Portrait, John Beiler

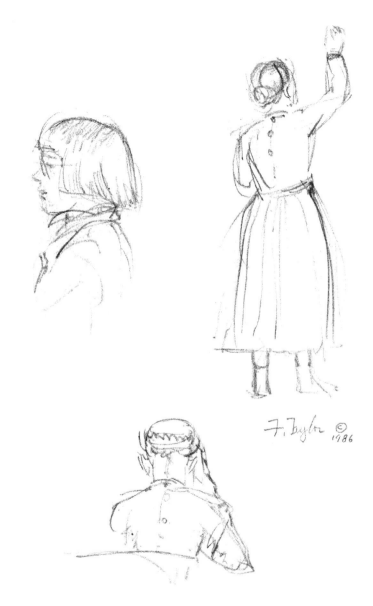

School Days

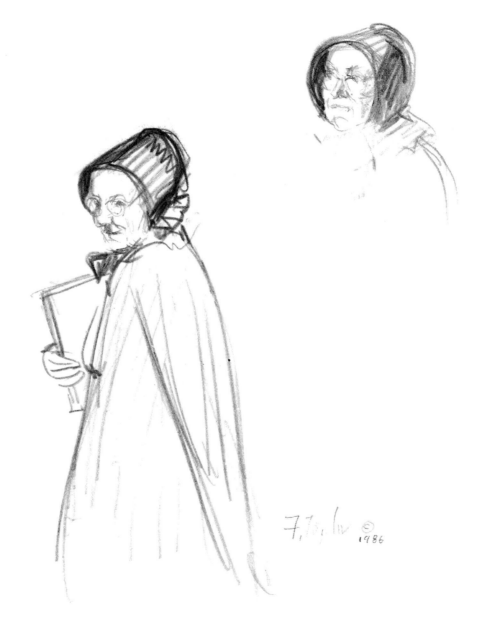

Going Her Own Way

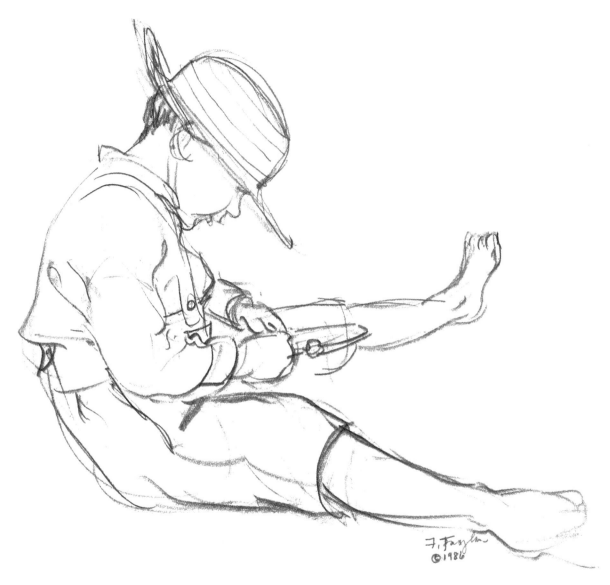

Boy Whittling

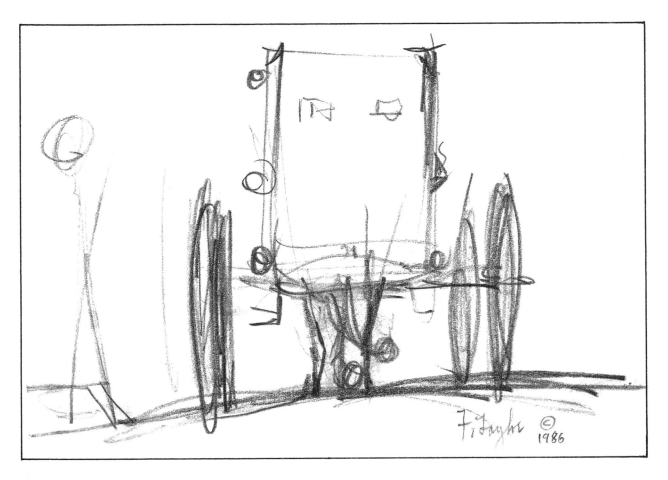

Going Home

About the Amish

A Christian religious group, the Amish trace their beginnings to the Protestant Reformation of the 16th century. Their roots extend to the Anabaptist part of that movement, which practiced adult, voluntary baptism. These reformers viewed the Bible as a normative guide for all of life, believed in separation of church and state, and refused to take part in war or any other form of violence.

One of the prominent Anabaptist leaders was Menno Simons, whose followers became known as Mennonites. The Amish are named for Jacob Amman, who split with the Mennonites in 1693 over issues concerning the maintenance of church purity.

Severely persecuted in European cities where the Anabaptist movement began, Amish and Mennonites fled to the countryside. Members of both groups came to North America in large numbers in the 1700s for the promise of religious freedom and rich farmland.

The Amish believe that faith is best lived within a community that is visibly separate from the outside world. Because of this, they use horses and buggies for transportation, dress in a modest and distinctive style and refrain from the use of electricity.

Readings and Sources

The Amish

Amish Cooking. Aylmer, Ontario: Pathway Publishing House, 1965.

Bender, H.S. **The Anabaptist Vision.** Scottdale, Pennsylvania: Herald Press, 1967.

The Budget. Sugarcreek, Ohio, 1890—. A weekly newspaper serving the Amish and conservative Mennonite communities in North America.

Devoted Christian's Prayer Book. Aylmer, Ontario: Pathway Publishing House, 1967.

Family Life. Amish periodical published monthly. Aylmer, Ontario: Pathway Publishing House.

Fisher, Sara and Rachel Stahl. **The Amish School.** Intercourse, Pennsylvania: Good Books, 1985.

Gingerich, Orland. **The Amish of Canada.** Waterloo, Ontario: Conrad Press, 1972.

Good, Merle. **Who Are the Amish?** Intercourse, Pennsylvania: Good Books, 1985.

_____ and Phyllis Pellman Good. **20 Most Asked Questions about the Amish and Mennonites.** Intercourse, Pennsylvania: Good Books, 1979.

Good, Phyllis Pellman and Rachel Thomas Pellman. **From Amish and Mennonite Kitchens.** Intercourse, Pennsylvania: Good Books, 1984.

Hostetler, John A. **Amish Life.** Scottdale, Pennsylvania: Herald Press, 1959.

_____ . **Amish Society.** Baltimore: Johns Hopkins University Press, 1963.

_____ and Gertrude E. Huntingdon. **Children in Amish Society.** New York: Holt, Rinehart and Winston, 1971.

Kaiser, Grace H. **Dr. Frau: A Woman Doctor Among the Amish.** Intercourse, Pennsylvania: Good Books, 1986.

Keim, Albert N. **Compulsory Education and the Amish.** Boston: Beacon Press, 1975.

Klaasen, Walter. **Anabaptism: Neither Catholic Nor Protestant.** Waterloo, Ontario: Conrad Press, 1972.

Ruth, John L. **A Quiet and Peaceable Life.** Intercourse, Pennsylvania: Good Books, 1985.

Scott, Stephen. **Plain Buggies.** Intercourse, Pennsylvania: Good Books, 1981.

———. **Why Do They Dress That Way?** Intercourse, Pennsylvania: Good Books, 1986.

———. **The Amish Wedding and Other Celebrations of the Old Order Communities.** Intercourse, Pennsylvania: Good Books, 1987.

Seitz, Ruth Hoover. **Amish Country.** New York: Crescent Books, 1987.

Steffy, Jan and Denny Bond, illus. **The School Picnic.** Children's book about the Amish for ages 4–8. Intercourse, Pennsylvania: Good Books, 1987.

Van Braght, Thieleman J., comp. **The Bloody Theatre;** or, **Martyrs Mirror.** Scottdale, Pennsylvania: Herald Press, 1951.

Amish Quilts and Crafts

Bishop, Robert and Elizabeth Safanda. **A Gallery of Amish Quilts.** New York: E. P. Dutton and Co., 1976.

Haders, Phyllis. **Sunshine and Shadow: The Amish and Their Quilts.** New York: Universe Books, 1976.

Horton, Roberta. **Amish Adventure.** Lafayette, California: C & T Publishing, 1983.

Lawson, Suzy. **Amish Inspiration.** Cottage Grove, Oregon: Amity Publications, 1982.

Pellman, Rachel T. **Amish Quilt Patterns.** Intercourse, Pennsylvania: Good Books, 1984.

——— and Kenneth Pellman. **Amish Crib Quilts.** Intercourse, Pennsylvania: Good Books, 1985.

——— and Kenneth Pellman. **Amish Doll Quilts, Dolls, and Other Playthings.** Intercourse, Pennsylvania: Good Books, 1986.

———. **Small Amish Quilt Patterns.** Intercourse, Pennsylvania: Good Books, 1985.

——— and Kenneth Pellman. **The World of Amish Quilts.** Intercourse, Pennsylvania: Good Books, 1984.

——— and Joanne Ranck. **Quilts Among the Plain People.** Intercourse, Pennsylvania: Good Books, 1981.

——— and Jan Steffy. **Patterns for Making Amish Dolls and Doll Clothes.** Intercourse, Pennsylvania: Good Books, 1987.

The Author

David Graybill, Lancaster, Pa., has worked as a newspaper reporter, freelance writer and radio station manager. Since January 1987, he has been assistant editor of **Festival Quarterly** magazine and assistant book editor at Good Books.

David is a native of Orrville, Ohio, and a 1978 graduate of Goshen College, Goshen, Ind. He earned a master's degree in English from the University of Virginia in 1987.